flora

Bones of pressed flowers

Asuka Tada

flora

花はただ咲いているだけだというのに、なぜか人々はその咲き姿や、無感情になされる生命の一連に、心の移ろいを重ねずにはいられない。とりわけ女たちは、かつてより花にたとえられることもしばしばで、それゆえ、女たちは色美しく、鮮やかな咲き姿に憧れ、羨み、命の短命さにいつかは色褪せるだろう自らを重ねてしまうのかもしれない。

女とは一体なんであろうという思考の中で、さまざまな個性をもった女たちの洋服を、化粧を、終いには皮膚や肉までもはぎ取ってしまった時、そこに残るのは女の本質の意を持った「骨」だった。その骨を、女の形容として用いられ、描かれてきた花というモチーフで再構成し、生まれたのが彼女floraである。

女というものを語るのは容易いことではない。しかし、私たちの生活にありふれている花を介して女を見つめることは、私たちを理解の入り口へと導いてくれるのではないだろうか。

本作品は女とは何かを定義するものではなく、長く深い理解の旅への導入装置にしかすぎないかもしれない。しかし、彼女は私の代わりに、女とはなにかを無言のうちにも語りかけてくれている。彼女のその無言の言葉にじっくりと耳を傾けて頂きたい。

flora

For some reason we cannot help associating ourselves with flowers, for example, with their general beauty and with their quiet, non-emotional, life-to-death passage, even when they are merely doing their mundane job of blooming. On many occasions, women are compared with flowers. Perhaps this explains why women tend to be attracted, feel envious, and/or are reminded of their eventual fading of youth against this colourful, vivid, but ephemeral beauty.

During the course of my reflection on what a woman is, I have imagined many women with individuality, starting off by removing her garments and make-up. Finally, I even removed her skin and flesh until all that remained were her "bones" which I felt was the essence of a woman. I have taken these bones as a metaphor for women, then re-combined them with a flower motif which gave birth to "flora".

It is not an easy task to speak about the idea of woman in a few short words. Perhaps observing flowers seen around us in our daily lives might be the first step to guide us to better understanding.

The objective of this artwork is not to define a woman. Perhaps it would act as a tool to facilitate preparation for the long, deep journey into understanding the idea of woman. On behalf of myself, she is apparently telling us quietly what a woman is. Please take your time to tune your ears to her whispers.

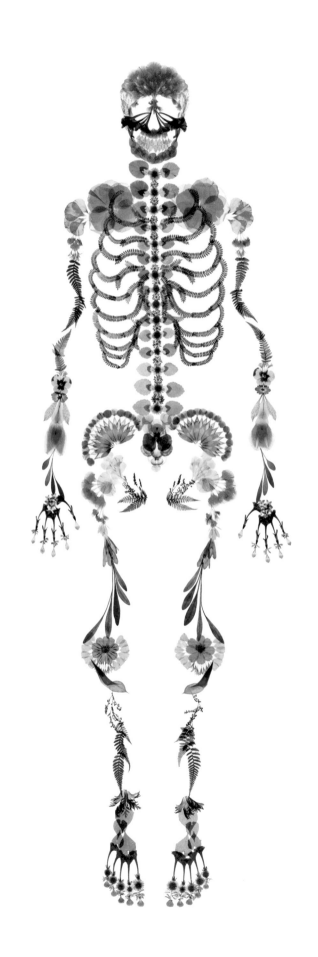

全身
the skeleton
front

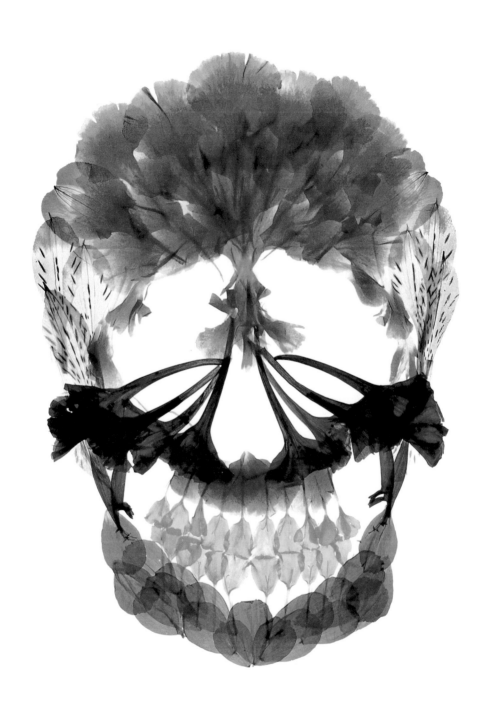

頭蓋骨

the skull
front

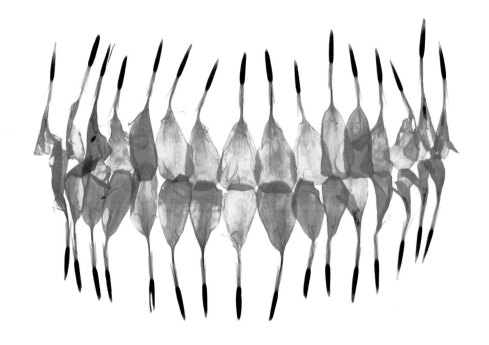

歯
the teeth
front

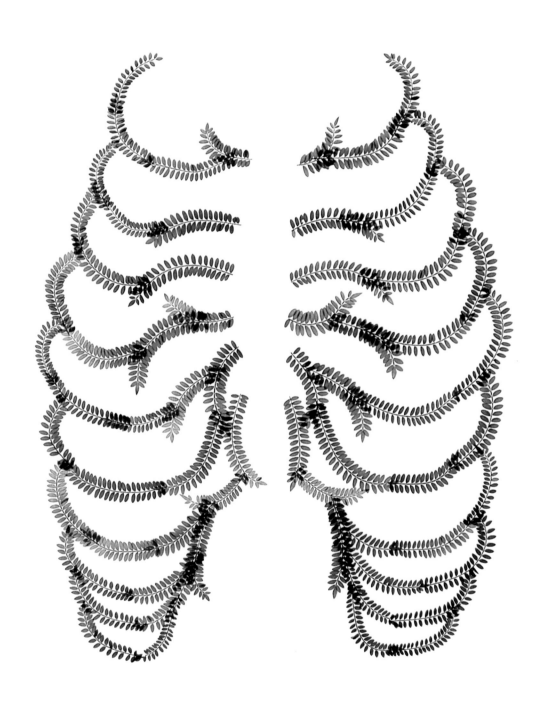

肋骨

the ribs

front

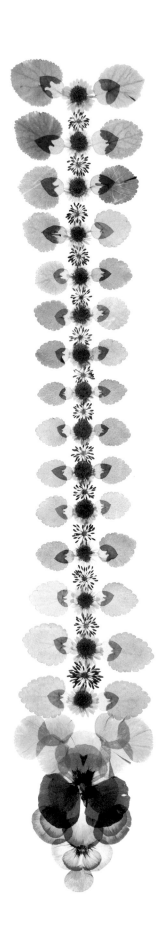

背骨
the backbone
front

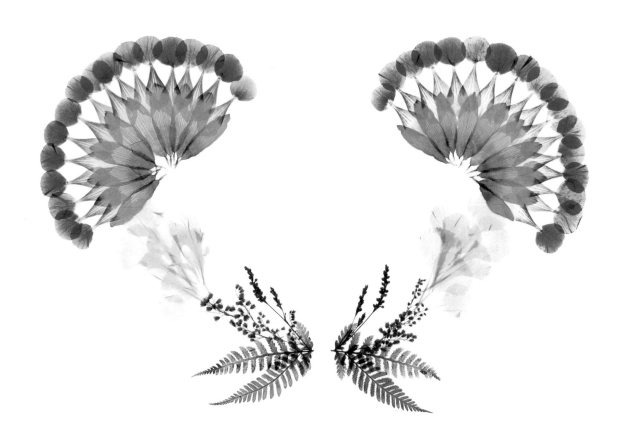

骨盤

the pelvis
front

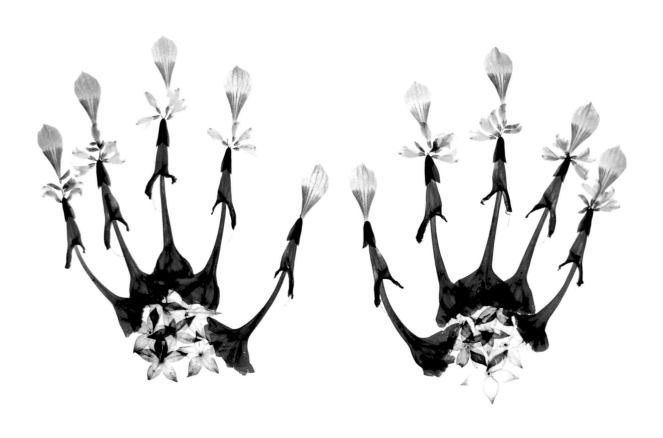

手

the hands
front

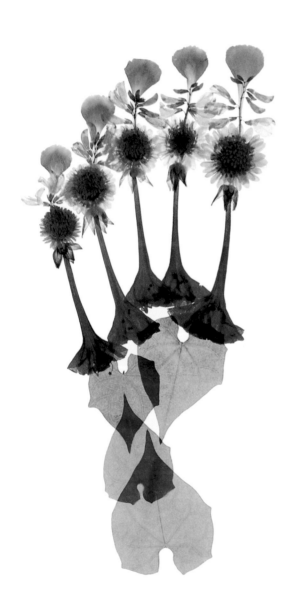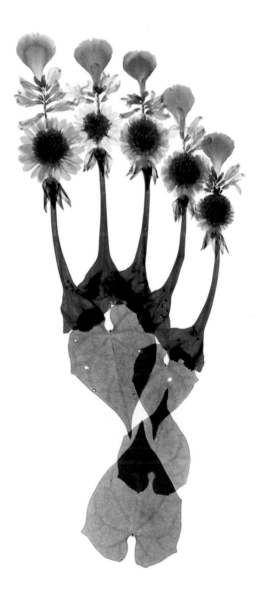

足

the feet
front

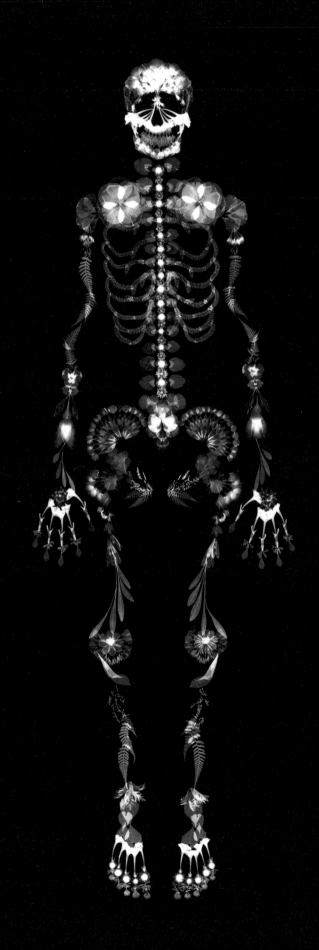

全身

the skeleton
front

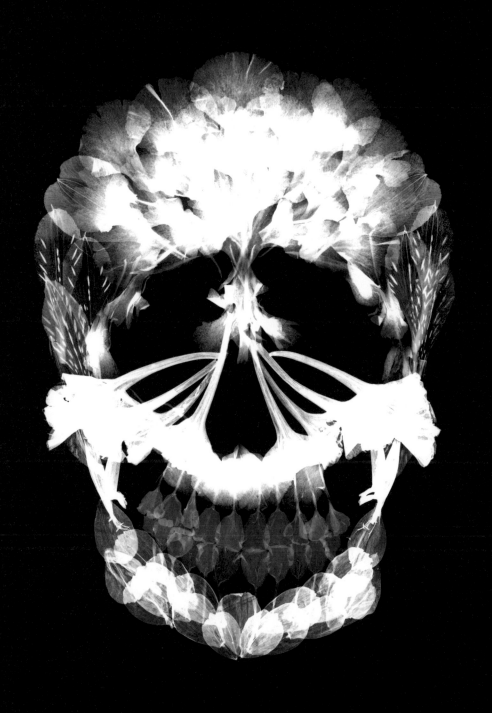

頭蓋骨

the skull
front

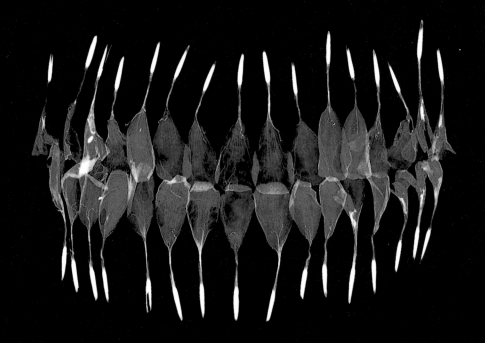

歯
the teeth
front

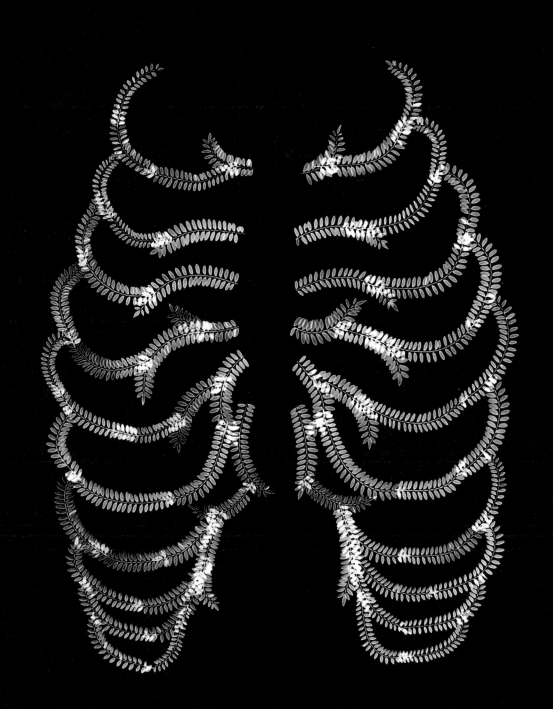

肋骨
the ribs
front

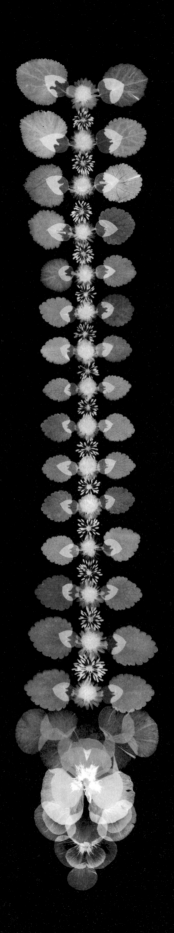

背骨
the backbone
front

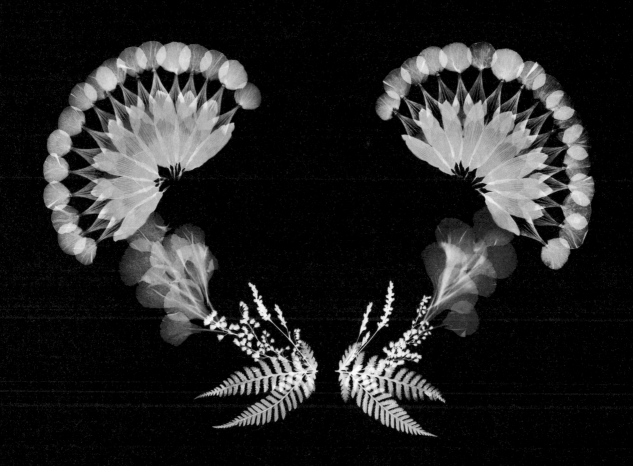

骨盤
the pelvis
front

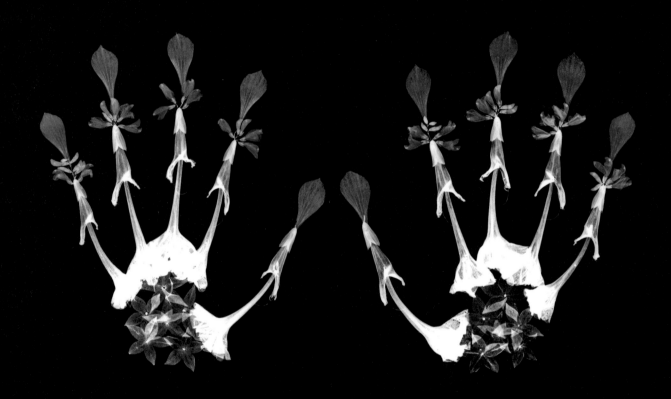

手

the hands
front

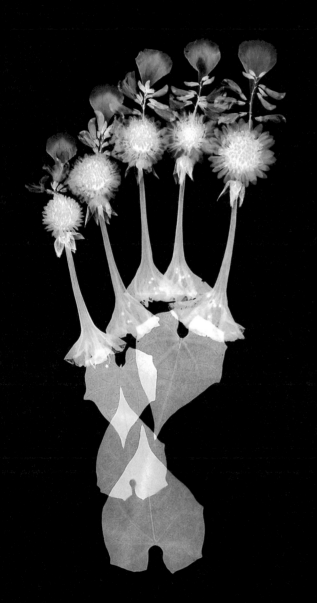
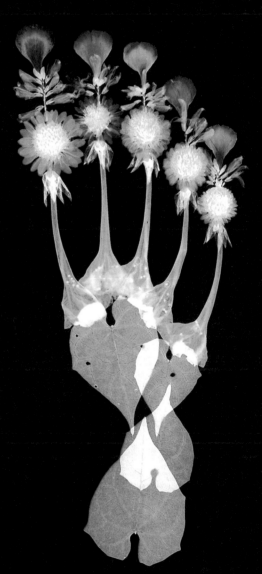

足
the feet
front

遠い場所

1974年、彼女は二度目の誕生日を迎えた。

彼女とは人類最古の化石、名前はルーシー。

320万年の間、大地という母胎で、ひっそりとこの日を待っていた。

320万年。

はてしなく、遠い場所だ。

彼女と私を繋ぐのは

「人類」「女」という言葉だけ。

しかし、彼女なくして、私は存在しないのかもしれない。

全てはつながっている。全て。

そして、私も誰かとつながっていく。

「人類」「女」として。

A Very Far Place

In 1974, she had her second birthday.

She is the oldest fossil to be found of humankind. Her name is Lucy.

She has been waiting quietly for 3.2 million years for this day for birth from her womb

by the name of earth.

3.2 million years…

an extremely distant place, far beyond our imagination.

The only words we have in common are "humankind" and "woman".

However, if not for her, I probably would not exist today.

Everything is connected. Everything.

I am also connected to someone

as "humankind" and as a "woman".

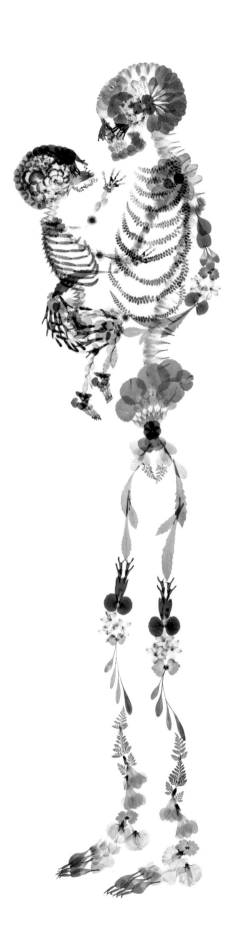

全身

the skeleton
side

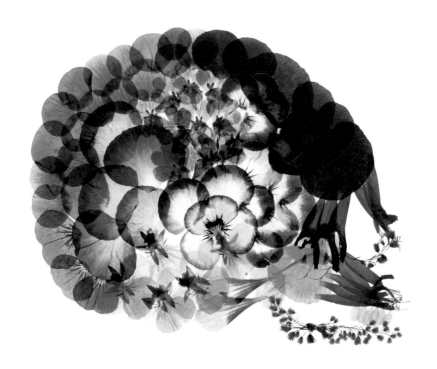

頭蓋骨

the skull
a daughter side

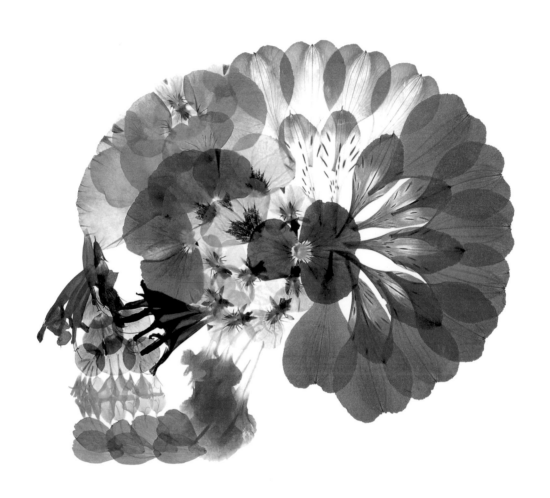

頭蓋骨

the skull
a mother side

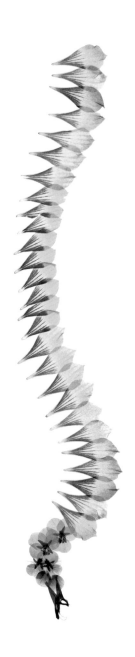

背骨

the backbone
a daughter side

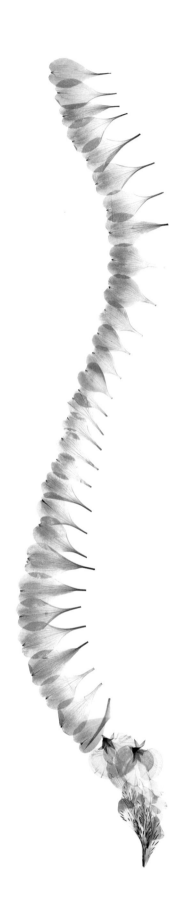

背骨

the backbone
a mother side

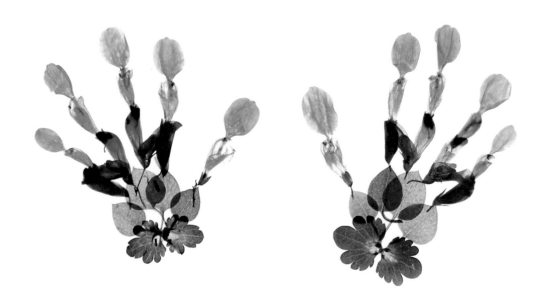

手

the hands
a daughter side

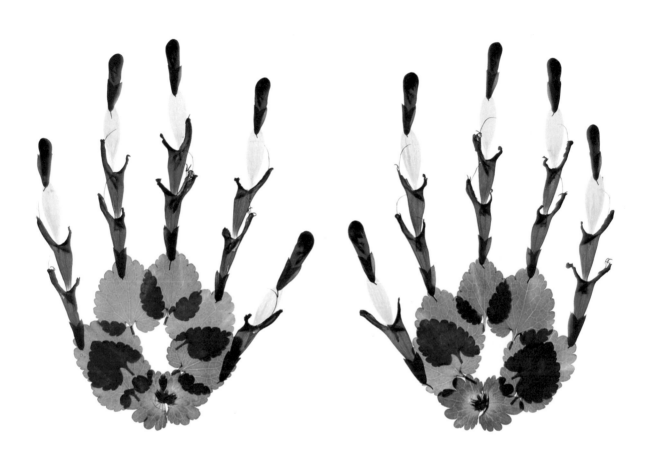

手

the hands
a mother front

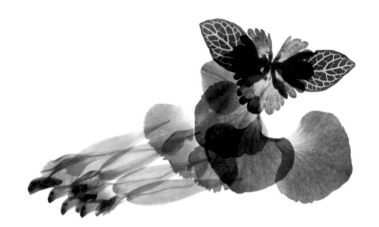

足

the foot
a daughter side

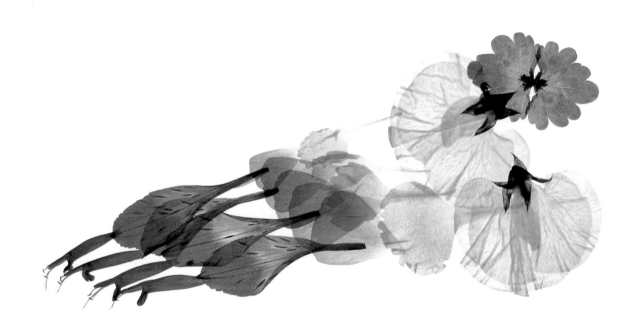

足

the foot
a mother side

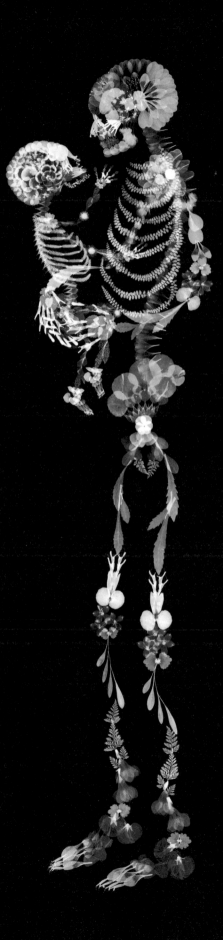

全身

the skeleton
side

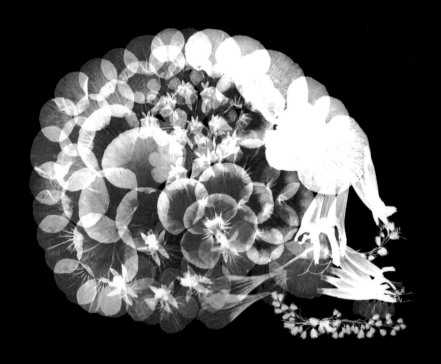

頭蓋骨

the skull
a daughter side

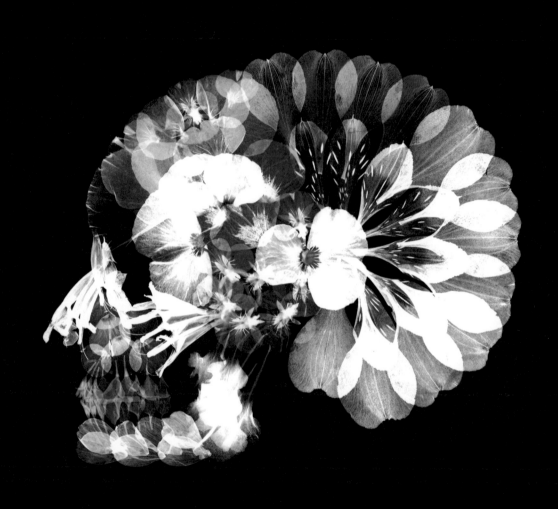

頭蓋骨

the skull
a mother side

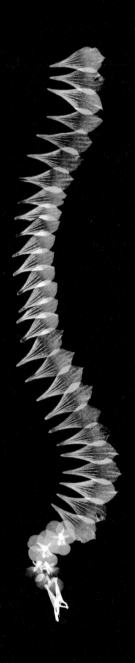

背骨

the backbone
a daughter side

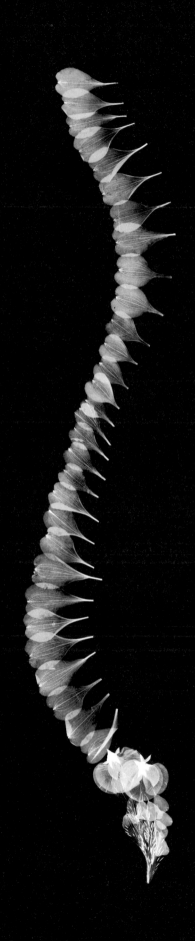

背骨

the backbone
a mother side

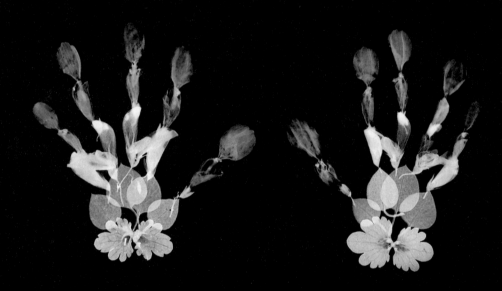

手

the hands
a daughter side

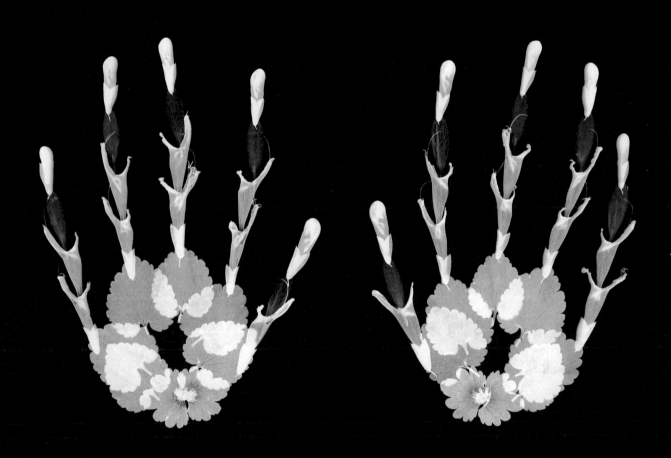

手

the hands
a mother front

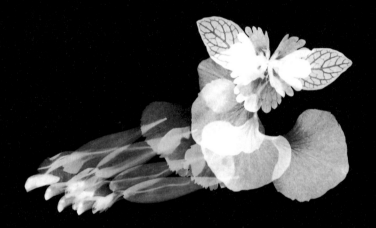

足

the foot
a daughter side

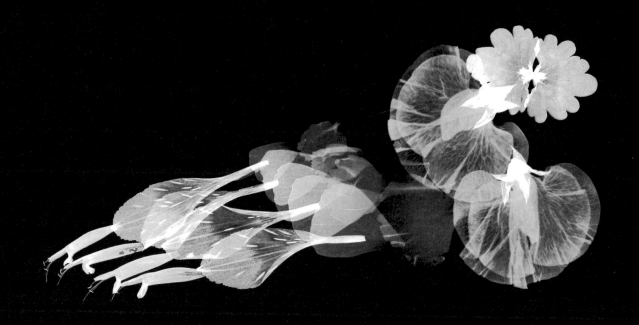

足

the foot
a mother side

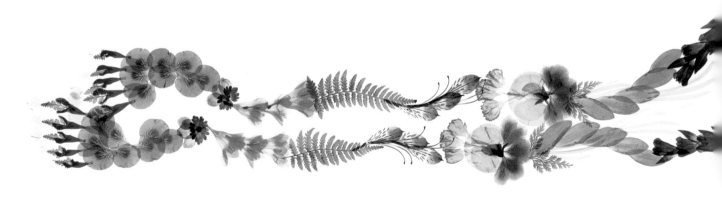

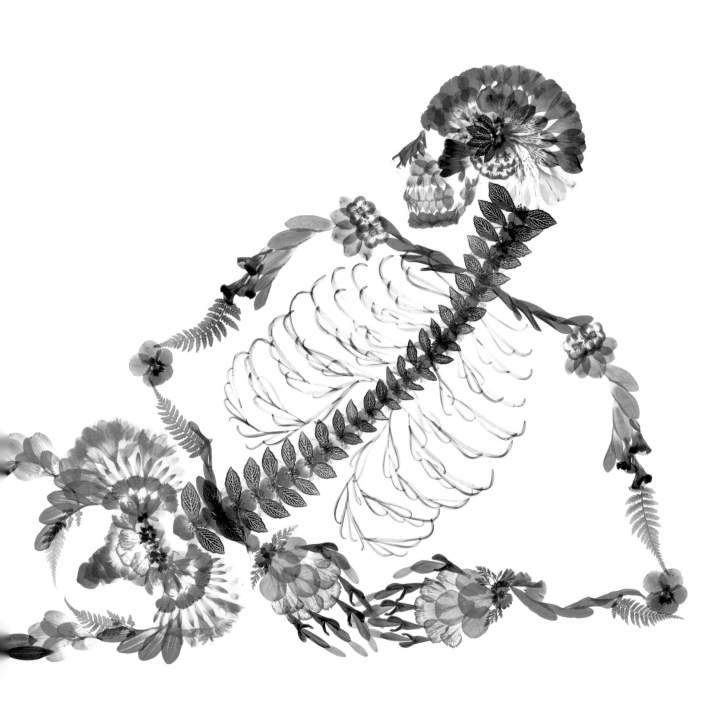

花

「花」という字。

それは「立つ人」と「倒さまに立つ人」の形をした、

「化」という字がもとになっているという。

それはすなわち、「生から死へと変わってゆく姿」を表しているという。

草が花となり、実へと変わっていく姿を「化」としたのか、

あるいは、死を宿命としたものとして、

人の生き死にをそこに重ねて「化」としたのだろうか。

Hana

The character of "hana" meaning flower in English, is said to be based on

the character of "ka" meaning change in English, ideographically

representing both "a standing person" and "a person standing on his head".

One might call it a "figure signifying change from life to death".

Did ancient people want to present the way that grass changes into a flower

and then a fruit using the character of "ka"?

Or did they, to express mortality, present a flower with "ka" by seeing it

loaded with another image of a person's life and death?

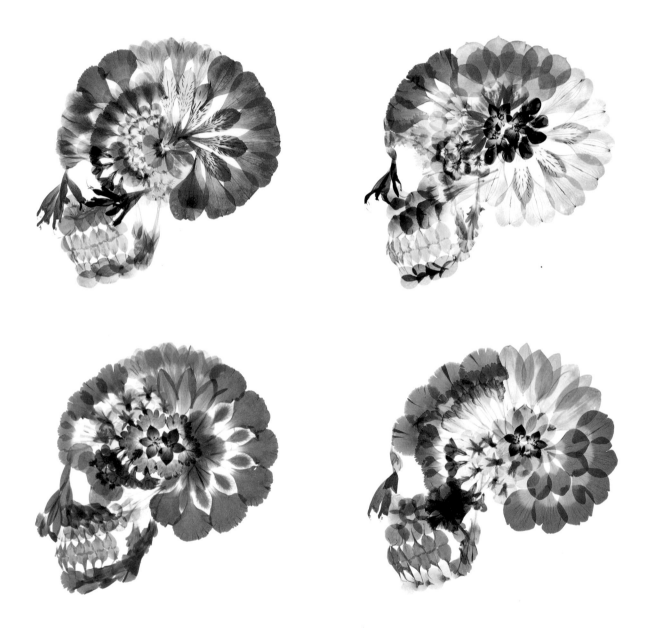

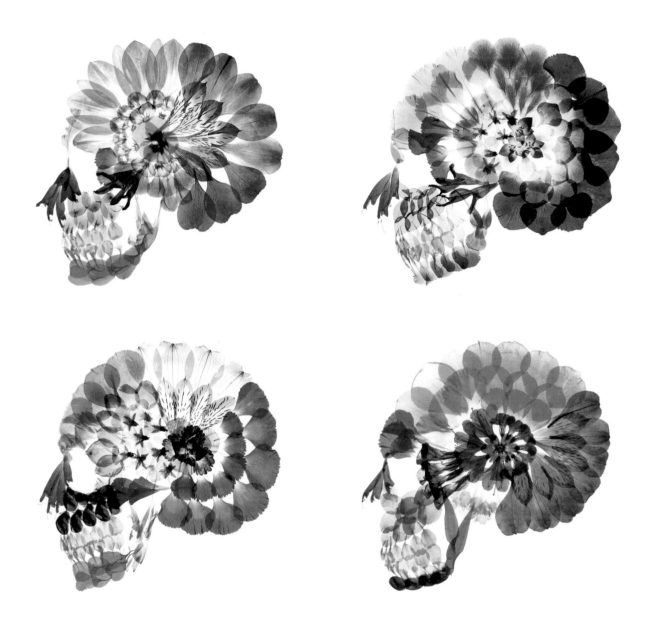

構成草花一覧

flora 01

全身｜the skeleton

アオガネシダ｜*Asplenium wilfordii* [愛嬌]
アルストロメリア｜*Alstroemeria pulchella* [エキゾチック]
イヌタデ｜*Polygonum longisetum* [あなたの役に立ちたい]
オシロイバナ｜*Mirabilis jalapa* [臆病]
カーネーション｜*Dianthus caryophyllus* [軽蔑]
ガーベラ｜*Gerbera jamesonii* [崇高美]
カラー｜*Zantedeschia aethiopica* [清浄]
キバナコスモス｜*Cosmos sulphureus* [野生美]
サルビアグアラニチカ｜*Salvia guaranitica* [知恵]
ジャカランダ｜*Jacaranda mimosifolia* [名誉]
セイタカアワダチソウ｜*Solidago altissima* [生命力]
チロリアンランプ｜*Abutilon megapotamicum* [恋の病]
チューリップ｜*Tulipa gesneriana* [告白]
トルコキキョウ｜*Eustoma grandiflorum* [優美]
ナツシロギク｜*Tanacetum parthenium* [集う喜び]
ニセアカシア｜*Robinia pseudoacacia* [慕情]
バラ｜*Rosa spp.* [情熱]
パンジー｜*Viola × wittrockiana* [物思い]
ビオラ｜*Viola × wittrockiana* [忠実]
フキ｜*Petasites japonicus* [待望]
ベニバナサルビア｜*Salvia coccinea* [燃ゆる想い]
ホワイトレースフラワー｜*Ammi majus* [繊細]
マリーゴールド｜*Tagetes patula* [嫉妬]
リンドウ｜*Gentiana scabra var. scabra* [正義]
ルドベキア｜*Rudbeckia hirta var. pulcherrima* [正しい選択]

頭蓋骨｜the skull

アルストロメリア｜*Alstroemeria pulchella* [エキゾチック]
オシロイバナ｜*Mirabilis jalapa* [臆病]
カーネーション｜*Dianthus caryophyllus* [軽蔑]
ベニバナサルビア｜*Salvia coccinea* [燃ゆる想い]
マリーゴールド｜*Tagetes patula* [嫉妬]

歯｜the teeth

マリーゴールド｜*Tagetes patura* [嫉妬]

肋骨｜the ribs

ジャカランダ｜*Jacaranda mimosifolia* [名誉]

背骨｜the backbone

ナツシロギク｜*Tanacetum parthenium* [集う喜び]
パンジー｜*Viola×wittrockiana* [物思い]
ビオラ｜*Viola×wittrockiana* [忠実]
フキ｜*Petasites japonicus* [待望]
ホワイトレースフラワー｜*Ammi majus* [繊細]

骨盤｜the pelvis

アオガネシダ｜*Asplenium wilfordii* [愛嬌]
イヌタデ｜*Polygonum longisetum* [あなたの役に立ちたい]
カーネーション｜*Dianthus caryophyllus* [軽蔑]
セイタカアワダチソウ｜*Solidago altissima* [生命力]
チロリアンランプ｜*Abutilon megapotamicum* [恋の病]
ビオラ｜*Viola × wittrockiana* [忠実]
ルドベキア｜*Rudbeckia hirata var. pulcherrima* [正しい選択]

手｜the hands

オシロイバナ｜*Mirabilis jalapa* [臆病]
サルビアグアラニチカ｜*Salvia guaranitica* [知恵]
チロリアンランプ｜*Abutilon megapotamicum* [恋の病]
フキ｜*Petasites japonicus* [待望]

足｜the feet

オシロイバナ｜*Mirabilis jalapa* [臆病]
カーネーション｜*Dianthus caryophyllus* [軽蔑]
ナツシロギク｜*Tanacetum parthenium* [集う喜び]
ニセアカシア｜*Robinia pseudoacacia* [慕情]

flora 02 [a mother]

全身 | the skeleton

アオガネシダ｜*Asplenium wilfordii* [夢]

アネモネ｜*Anemone coronaria* [辛抱]

アルストロメリア｜*Alstroemeria pulchella* [援助]

カーネーション｜*Dianthus caryophyllus* [母の愛]

ガーベラ｜*Gerbera jamesonii* [律儀]

キバナコスモス｜*Cosmos sulphureus* [野生美]

サルビアグアラニチカ｜*Salvia guaranitica* [家庭の徳]

スイートピー｜*Lathyrus odoratus* [門出]

チロリアンランプ｜*Abutilon megapotamicum* [憶測]

トルコキキョウ｜*Eustoma grandiflorum* [花嫁の感傷]

ネフロレピス｜*Nephrolepis exaltata* [愛らしさ]

バラ｜Rosa spp. [無邪気]

パンジー｜*Viola × wittrockiana* [心の平和]

ビオラ｜*Viola × wittrockiana* [信頼]

フキ｜*Petasites japonicus* [公平]

フリージア｜*Freesia refracta* [期待]

ベニバナサルビア｜*Salvia coccinea* [良い家庭]

ホトケノザ｜*Lamium amplexicaule* [調和]

マリーゴールド｜*Tagetes patula* [変わらぬ愛]

リンドウ｜*Gentiana scabra ver. scabra* [淋しい愛情]

頭蓋骨 | the skull

アルストロメリア｜*Alstroemeria pulchella* [援助]

カーネーション｜*Dianthus caryophyllus* [母の愛]

キバナコスモス｜*Cosmos sulphureus* [野生美]

サルビアグアラニチカ｜*Salvia guaranitica* [家庭の徳]

トルコキキョウ｜*Eustoma grandiflorum* [花嫁の感傷]

パンジー｜*Viola × wittrockiana* [心の平和]

ビオラ｜*Viola × wittrockiana* [信頼]

ベニバナサルビア｜*Salvia coccinea* [良い家庭]

マリーゴールド｜*Tagetes patula* [変わらぬ愛]

背骨 | the backbone

アルストロメリア｜*Alstroemeria pulchella* [援助]

スイートピー｜*Lathyrus odoratus* [門出]

マリーゴールド｜*Tagetes patula* [変わらぬ愛]

手 | the hands

ガーベラ｜*Gerbera jamesonii* [律儀]

サルビアグアラニチカ｜*Salvia guaranitica* [家庭の徳]

フキ｜*Petasites japonicus* [公平]

ホトケノザ｜*Lamium amplexicaule* [調和]

足 | the foot

アルストロメリア｜*Alstroemeria pulchella* [援助]

カーネーション｜*Dianthus caryophyllus* [母の愛]

スイートピー｜*Lathyrus odoratus* [門出]

トルコキキョウ｜*Eustoma grandiflorum* [花嫁の感傷]

ベニバナサルビア｜*Salvia coccinea* [良い家庭]

ホトケノザ｜*Lamium amplexicaule* [調和]

flora 02 [a daughter]

全身 | the skeleton

アルストロメリア | *Alstroemeria pulchella* [未来への憧れ]

カーネーション | *Dianthus caryophyllus* [感動]

ガーベラ | *Gerbera jamesonii* [冒険心]

キバナコスモス | *Cosmos sulphureus* [野生美]

サルビアグアラニチカ | *Salvia guaranitica* [エネルギー]

スイートアリッサム | *Lobularia maritima* [飛躍]

スイートピー | *Lathyrus odoratus* [永遠の喜び]

セイタカアワダチソウ | *Solidago altissma* [元気]

チロリアンランプ | *Abutilon megapotamicum* [様々な愛]

トルコキキョウ | *Eustoma grandiflorum* [清美]

ナツシロギク | *Tanacetum parthenium* [寛容]

ネメシア | *Nemesia floribunda* [包容力]

パンジー | *Viola × wittrockiana* [愛の使者]

ビオラ | *Viola × wittrockiana* [少女の恋]

フキ | *Petasites japonicus* [待望]

ベニバナサルビア | *Salvia coccinea* [尊敬]

ホトケノザ | *Lamium amplexicaule* [輝く心]

マリーゴールド | *Tagetes patula* [健康]

頭蓋骨 | the skull

サルビアグアラニチカ | *Salvia guaranitica* [エネルギー]

セイタカアワダチソウ | *Solidago altissima* [元気]

チロリアンランプ | *Abutilon megapotamicum* [様々な愛]

ナツシロギク | *Tanacetum parthenium* [寛容]

ネメシア | *Nemesia floribunda* [包容力]

パンジー | *Viola × wittrockiana* [愛の使者]

ビオラ | *Viola × wittrockiana* [少女の恋]

ベニバナサルビア | *Salvia coccinea* [尊敬]

背骨 | the backbone

サルビアグアラニチカ | *Salvia guaranitica* [エネルギー]

チロリアンランプ | *Abutilon megapotamicum* [様々な愛]

ビオラ | *Viola × wittrockiana* [少女の恋]

手 | the hands

ナツシロギク | *Tanacetum parthenium* [寛容]

フキ | *Petasites japonicus* [待望]

ホトケノザ | *Lamium amplexicaule* [輝く心]

足 | the foot

ガーベラ | *Gerbera jamesonii* [冒険心]

ナツシロギク | *Tanacetum parthenium* [寛容]

フキ | *Petasites japonicus* [待望]

ホトケノザ | *Lamium amplexicaule* [輝く心]

flora 03

全身 | the skeleton

アオガネシダ | *Asplenium wilfordii* [魅惑]

アジサイ | *Hydrangea macrophylla* [冷淡]

アルストロメリア | *Alstroemeria pulchella* [凛々しさ]

カーネーション | *Dianthus caryophyllus* [熱愛]

ガーベラ | *Gerbera jamesonii* [前進]

キク | *Chrysanthemum morifolium* [破れた恋]

サルビアグアラニチカ | *Salvia guaranitica* [燃ゆる想い]

ダリア | *Dahlia pinnate* [優雅]

デルフィニウム | *Delphinium grandifloram* [移り気]

トレニア | *Torenia fournieri* [可憐な欲望]

ハボタン | *Brassica oleracea var. acephala* [慈愛]

パンジー | *Viola × wittrockiana* [物思い]

ビオラ | *Viola × wittrockiana* [誠実]

ピンクッション | *Leucospermum cordifolium* [陽気]

フィットニア | *Fittonia verschaffeltii* [羨ましい]

ブプレウルム | *Bupleurum rotundifolium* [希望]

フリージア | *Freesia refracta* [憧れ]

ベニバナサルビア | *Salvia coccinea* [知恵]

ペラルゴニウム | *Pelargonium × domesticum* [決心]

ホトケノザ | *Lamium amplexicaule* [調和]

ホワイトレースフラワー | *Ammi majus* [悲哀]

マリーゴールド | *Tagetes patula* [絶望]

リンドウ | *Gentiana scabra var. scabra* [貞節]

頭蓋骨 ｜ the skull

アルストロメリア ｜ *Alstroemeria pulchella* [幸福な日々]

カーネーション ｜ *Dianthus caryophyllus* [熱愛]

サルビアグアラニチカ ｜ *Salvia guaranitica* [素朴]

ダリア ｜ *Dahlia pinnata* [優雅]

デルフィニウム ｜ *Delphinium grandiflorum* [軽やか]

バコパ ｜ *Sutera cordata* [小さな強さ]

パンジー ｜ *Viola × wittrockiana* [心の平和]

ビオラ ｜ *Viola × wittrockiana* [謙遜]

ベニバナサルビア ｜ *Salvia coccinea* [全て良し]

マリーゴールド ｜ *Tagetes patula* [友情]

ワトソニア ｜ *Watsonia angusta* [豊かな心]

頭蓋骨 ｜ the skull

アジサイ ｜ *Hydrangea macrophylla* [無情]

アルストロメリア ｜ *Alstroemeria pulchella* [華奢]

カーネーション ｜ *Dianthus caryophyllus* [美しい仕草]

サルビアグアラニチカ ｜ *Salvia guaranitica* [尊敬]

ダリア ｜ *Dahlia pinnata* [華麗]

ハコベ ｜ *Stellaria neglecta* [追想]

バラ ｜ *Rosa spp.* [上品]

ビオラ ｜ *Viola × wittrockiana* [誠実]

ブプレウルム ｜ *Bupleurum rotundifolium* [希望]

プリムラジュリアン ｜ *Primula × polyantha* [無言の愛]

ベニバナサルビア ｜ *Salvia coccinea* [知恵]

マリーゴールド ｜ *Tagetes patula* [真心]

ルピナス ｜ *Lupinus polyphyllus* [安らぎ]

頭蓋骨 ｜ the skull

カーネーション ｜ *Dianthus caryophyllus* [愛の拒絶]

ガーベラ ｜ *Gerbera jamesonii* [冒険心]

ダリア ｜ *Dahlia pinnata* [移り気]

デルフィニウム ｜ *Delphinium grandiflorum* [気まぐれ]

バコパ ｜ *Sutera cordata* [愛らしい]

パンジー ｜ *Viola × wittrockiana* [物思い]

ブプレウルム ｜ *Bupleurum rotundifolium* [希望]

ペラルゴニウム ｜ *Pelargonium × domesticum* [艶やか]

ホトケノザ ｜ *Lamium amplexicaule* [愛嬌]

マリーゴールド ｜ *Tagetes patula* [嫉妬]

ワトソニア ｜ *Watsonia angusta* [知性]

頭蓋骨 ｜ the skull

アネモネ ｜ *Anemone coronaria* [辛抱]

カーネーション ｜ *Dianthus caryophyllus* [感動]

ダリア ｜ *Dahlia pinnata* [不安定]

デルフィニウム ｜ *Delphinium grandiflorum* [清明]

バコパ ｜ *Sutera cordata* [小さな強さ]

ビオラ ｜ *Viola × wittrockiana* [控えめ]

ブプレウルム ｜ *Bupleurum rotundifolium* [希望]

プリムラジュリアン ｜ *Primula × polyantha* [運命をひらく]

ベニバナサルビア ｜ *Salvia coccinea* [恋情]

マリーゴールド ｜ *Tagetes patula* [真心]

頭蓋骨 ｜ the skull

アルストロメリア ｜ *Alstroemeria pulchella* [気配り]
カーネーション ｜ *Dianthus caryophyllus* [母の愛]
サルビアグアラニチカ ｜ *Salvia guaranitica* [知恵]
ダリア ｜ *Dahlia pinnata* [威厳]
デルフィニウム ｜ *Delphinium grandiflorum* [慈悲]
パンジー ｜ *Viola × wittrockiana* [遠慮]
ビオラ ｜ *Viola × wittrockiana* [信頼]
ベニバナサルビア ｜ *Salvia coccinea* [家族愛]
マリーゴールド ｜ *Tagetes patula* [健康]

頭蓋骨 ｜ the skull

アジサイ ｜ *Hydrangea macrophylla* [冷淡]
カーネーション ｜ *Dianthus caryophyllus* [軽蔑]
サルビアグアラニチカ ｜ *Salvia guaranitica* [尊重]
ハコベ ｜ *Stellaria neglecta* [追想]
ビオラ ｜ *Viola × wittrockiana* [控えめ]
ブプレウルム ｜ *Bupleurum rotundifolium* [希望]
プリムラジュリアン ｜ *Primula × ployantha* [無言の愛]
ベニバナサルビア ｜ *Salvia coccinea* [知恵]
ペラルゴニウム ｜ *Pelargonium × domesticum* [望み]
マリーゴールド ｜ *Tagetes patula* [悲しみ]

頭蓋骨 ｜ the skull

アルストロメリア ｜ *Alstroemeria pulchella* [機敏]
カーネーション ｜ *Dianthus caryophyllus* [熱愛]
デルフィニウム ｜ *Delphinium grandiflorum* [陽気]
バラ ｜ *Rosa spp.* [無邪気]
パンジー ｜ *Viola × wittrockiana* [天真爛漫]
ビオラ ｜ *Viola × wittrockiana* [信頼]
ベニバナサルビア ｜ *Salvia coccinea* [燃ゆる想い]
ホトケノザ ｜ *Lamium amplexicaule* [愛嬌]
マリーゴールド ｜ *Tagetes patula* [勇者]
ルピナス ｜ *Lupinus polyphyllus* [貪欲]

頭蓋骨 ｜ the skull

アルストロメリア ｜ *Alstroemeria pulchella* [持続]
カーネーション ｜ *Dianthus caryophyllus* [母の愛]
ガーベラ ｜ *Gerbera jamesonii* [我慢強さ]
ツツジ ｜ *Rhododendron sp.* [自制心]
デルフィニウム ｜ *Delphinium grandiflorum* [高貴]
トレニア ｜ *Torenia fournieri* [温和]
バラ ｜ *Rosa spp.* [模範]
ベニバナサルビア ｜ *Salvia coccinea* [知恵]
ホトケノザ ｜ *Lamium amplexicaule* [調和]
マリーゴールド ｜ *Tagetes patula* [友情]
ルピナス ｜ *Lupinus polyphyllus* [多くの仲間]

一つの花に対して複数の花言葉が存在していることがありますが、それは国や地域、民族や宗教によって花や植物に対する思いや捉え方がそれぞれ違うからです。ここに記載している花言葉は複数ある花言葉から、作品ごとに合った花言葉を選び記載しています。

Sometimes multiple flower languages can exist for one flower because our feelings and how we perceive flowers differ depending on the country, region, race, and religion. The flower languages written here are selected based on what is regarded as the best match for each artwork.

植物と女

西畠清順

花や木など、自然の植物やそのかけらを素材として使う芸術、例えばフラワーデザインや現代いけばなは、「花をいかにきれいに魅せるか」「葉をいかにうまく使うか」などを重点において作品をつくるものだ。しかし、今回のように「女」というテーマのもと、アートを創造するうえでその素材として「たまたま植物のかけらが用いられた」という点が興味深いように思う。自然の素材（≠植物）を使ってなにかを表現したり作品づくりをするすべての芸術家に対して、肯定的でいたいと思っている僕は、自分の仕事柄、数え切れないほど植物を用いた作品を目にしてきたが、作者のつくったものを見てまずおもしろいと思った点がそこだった。

素材として植物を使う、という前提で作品づくりを重ねていくと、人間ならだれしもその魅力にとり付かれ、尊敬の念を抱き、どんどん植物そのものと向きあうようになっていく。しかし、この作品のケースはちょっと違っていて、若い女である作者ならではの、いい意味で "植物でなければならなかった" 感がない。花をいかにきれいに見せるかという意図的な演出がなく、思考のすえ、たまたま身近に手にいれることができた植物素材で構成された、そんなある意味ピュアなその偶然性がおもしろいのだと思う。

言ってみれば、男という存在が女にとって人生最大のテーマであるように、女は男にとってもまさに人生そのものだ。いや、もっと言うと、男にとって女は本当に未知の世界でもある。僕は、芸術うんぬんを語れるほどの才覚をもちあわせてはいないが、結局それ（芸術）を見るのは世の中で男か女しかいない。そんな当たり前のことを前提にしたとき、女の体のなかにある骸骨を想像しながら、ひたすら外を歩いて花を捜し、葉を拾い、茎を摘んで集め、夢中でアクリル板の上に並べている一人の若い女の姿を、その時間を、男としては想像してみたくさせるような作品にもなっているだろうと思う。また、作者は「女の内面にある本質を、骸骨にたとえて表現したかった」という。女は、男以上に繊細で、複雑で、脆くて、そして強い。そういった表現力をもったこの作品は、これを見る女に対しても大いに説得力があるものになっているのではないか、と思う。

これらのおもしろい要素が偶然的にありながらも、作品自体もまた、素直に「きれい」と形容できるものに仕上がっていることもまた、最後に触れておきたい。

西畠清順｜プラントハンター

明治元年創業の植物卸問屋「花宇」5代目。
国内外を旅し、収集・生産する植物は数千種類。2012年、ひとの心に植物を植える活動 "そら植物園" をスタート。様々な企業・団体・個人と植物を使ったプロジェクトを多数進行中。

Plants and woman

Seijun Nishihata

Flower Arts such as Flower Designs or Contemporary Ikebanas, commonly known to use materials from natural flowers or trees or from fragments thereof is all about creation, emphasizing ways to "express the flower as beautifully as possible" or "to use the leaf most effectively".

However, for this artwork, I find it the most interesting that "it just so happens that" the fragments of plants were used as a material to realize this artwork's theme, "Woman".

I see myself rather affirmative for artists that use natural materials to express and/or to create artwork. Because of the character of my profession, I have seen countless artwork using plants, but this is where I found it interesting with this particular artwork.

Normally when one uses plants as materials to create an artwork, we become fascinated with the beauty and even develop a sense of respect towards the plants. This artwork is a bit of a positive exception where this young female artist nonchalantly makes us feel that "the use of flowers was not mandatory". No intentional direction was given to express the flower as beautifully as possible, but upon consideration, she "just so happened" to use a plant material with which she was familiar and to which she had easy access. I find this pure thinking aspect to be the most interesting.

As the existence of a man is a major theme for a woman, a woman is the life itself for a man. Moreover, for a man, a woman is an unknown world. I have not much wit to lecture about art, but at the end of the day, the audience for the art is either a man or a woman. With this natural mindset, as a man, this artwork makes me want to imagine the scene or the time of where this skeleton within this young woman's body is earnestly walking around to find the flowers, pick up the leaves, collect the stems, engrossed completely in lining them up on top of her acrylic board. Furthermore, according to this artist, she wanted to, "express the woman's true inner nature through a skeleton". A woman is more delicate, complex, fragile, and yet stronger than a man. I imagine that this statement from this artwork is persuasive to women viewers as well.

On top of these interesting components that coincidentally compose this artwork, lastly, I would like to describe this overall finish utterly as "beautiful".

Seijun Nishihata | Plant Hunter

5th Generation of Plant Wholesaler, Hanau established in the Meiji Era (1968). Travelling around the world, he has collected and produced well around a couple of thousand types of plants. In 2012, he commenced an activity of planting plants on people's hearts called "Sora Shokubutsuen". Many projects are in progress involving plants with individuals, organizations, and corporations.

生と死、花と女

原研哉

「flora」が新たな文脈で再来することを心から喜びたい。書籍として生まれ変わることで、この作品が投げかけている秀逸な問いが、多くの人々の感覚に新たな共振を生み出していくことを期待したい。

多田明日香の作品「flora」は、2009年度の武蔵野美術大学基礎デザイン学科の卒業制作であった。その年の僕のゼミのテーマは「女」であった。「女」に対するモチーフとして「花」は比較的自然に見えるかもしれないが、押し花を精緻に並べて、カラフルなレントゲン写真のように「女」を表現するというのは非常に特異な視点である。僕たちの試みは「女」について新たな解釈を加えるような姿勢ではなく、「いかに女を知らなかったか」を覚醒させていく道筋を示そうとするものであったが、それにしても多田の視点は際立っていた。

不思議なのは、なぜ多田が「押し花」で「女の骨」を表現したかである。考えてみると僕たちは「女」について分かっていないだけではなく「花」についても分かっていないことに気づく。あたりまえのように人は花を買い、花を飾り、花を植える。植物も、そういう営みにあらがうこともなく、香しく花を咲かせ、人々の潜在的な希求に応えている。しかし「花」とは何かと問われるとたちまち僕らは返答に窮する。

かつて岡倉天心は「茶の本」の末尾で、花について言及していた。もしも花がなければ、人間は生き死にに随分と不都合を来すだろう、それほどに人は無意識に「花」に頼り、その魅力にすがって自分たちの力の及ばない事象に耐えている、というような事柄だった。多田の視点はこの岡倉天心の指摘に近接している。押し花という、生の領域から死の領域へと移行しつつある花の姿で造形された女の骨。それが絶妙なる美しさで表現されていることで、私たちは、知らず接している生死の深淵とそこに生じる畏れと感動の本質へ、思考の集中を誘われていくのである。女も花も生への喜びと死の厳粛さを止揚するところにその存在があるのかもしれない。そこに生じる美的な感慨は、それらを見つめるものの心中に沸き上がる心象そのものである。

卒業して二年を経過したのちに、多田はこれを一冊の書籍として表現しようとしている。その試みを僕は素直に喜びたい。多田明日香はおそらくは、何者かになりかけている自身に無意識に突き動かされつつ、その基点にこの作品を位置づけてみたいのだと思うが、一連の作品は、本人の思いを越えて多くの人に必要とされるに違いないだろうから。

原研哉｜グラフィックデザイナー
武蔵野美術大学教授。日本デザインセンター代表。
長野オリンピックの開・閉会式プログラムや愛知万博ポスター、無印良品のアートディレクション、代官山蔦屋書店などを手がける。デザインも可能性を示唆する展覧会を企画・制作し世界各地を巡回。著書『デザインのデザイン』や『白』は多言語に翻訳され、国内外に多数の読者を持つ。

Life and Death,
Flower and Woman

Kenya Hara

It is with my utmost pleasure to learn that "flora" is making its reincarnation through a different context. By re-entering this world as a book this time, I look forward to seeing new resonations brought upon the sensations of many people triggered by the brilliant inquiry that this work presents to us.

Asuka Tada's "flora" was her graduation artwork from the Department of Science of Design of Musashino Art University in 2009. In that particular year, the theme at the seminar I was teaching was "woman". At first it seems natural to use a "flower" as a motif for "woman". However, we felt that the idea to collage pressed flowers meticulously, in such fine details to express a "woman" as if it was almost a colourful x-ray, was such an extreme, unique perspective. Our objective was not merely to get the student's own interpretation of "woman", but to create an indicator to an awakening opportunity; to have the students realize "that they actually do not know of woman at all". Nevertheless, Tada's perspective was conspicuous.

It remains as a wonder why Tada decided to express a "woman's bones" through "pressed flowers". Come to think of it, not only do we realize that we do not understand "woman" but we also do not know anything about flowers at all. In our everyday life, we buy flowers, decorate flowers, and plant flowers, taking them for granted. Plants show no resistance and just go about their usual business of flowering and spreading nice scents, pleasing our subconscious desires. However, at the moment when we are asked to define what a "flower" is, we are at a loss for an answer.

Earlier, Tenshin Okakura, a Japanese writer and art curator, writes about flowers in the ending of his famous book, "The Book of Tea". He mentions that if there were no flowers on this earth, there would be a great deal of inconvenience with the life and death of humans. This is how much humans unconsciously rely on "flowers" and depend on the beauty to endure events beyond our scope. Tada's perspective is in a way close to the insights by Tenshin Okakura. The woman's bones are formed by the pressed flowers; flowers that are "in-progress" of transformation from life to death. With these flowers being expressed with such exquisite beauty, our concentration of our thoughts is invited unconsciously to the abyss of life and death and the true nature for fear and excitement. Perhaps the existence of woman and flower lies in the sublation from both the joy of life and solemnity of death. The deep aesthetical emotion that arises is a direct reflection of what they see and is portrayed to their mind exactly as is.

Only after two years following her graduation, Tada is trying to express her work through a book. I am truly delighted with her challenge. I imagine that Asuka Tada is being driven by her unconscious, "on my way to becoming someone special" self-motivation, and is thereby trying to mark her pivot point through this work. However, I believe her series of work will bring great demand from many people, surpassing her expectations.

Kenya Hara | Graphic Designer
Professor at Musashino Art University / Representative of Nippon Design Center Inc.
Worked on the programs for the Opening and Closing Ceremonies of the Nagano Winter Olympic Games and posters for the Expo 2005 Aichi, works as the Art Director for MUJI, TSUTAYA Shoten Daikanyama, and such Plans and produces various exhibition with potential in design taking place in various part of the world. Authored books such as "Design of Design" and "White" have been translated into multiple languages, with many readers worldwide.

あとがき

気づけば彼女floraが生まれてから2年半以上の月日が経ち、彼女と向き合う日々の中で私は、再び途方に暮れてしまうこととなった。「女とは」という問に対して無尽蔵に並べられる回答の多さに改めて気づかされたのである。そのことに気づかされたのは「flora」という言葉であった。floraとはローマ神話にでてくる春の女神のことであり、これは私が本作品には花のような響きを持った女性の名前を付けようと行き着いたなによりの理由だったが、実はもう一つの意味があったのだ。それは「植物相」と言う意味だ。

植物相とは、時代や地域、気候、自然環境によってそこに生息する植物の種類組織のことである。例えば、日本とアフリカとではその環境の違いによって全く異なる種類の植物が生息しているといった具合に、植物は様々な条件の下に各種の植物相にグループ化されるのだ。女もまた一緒である。私の暮らす文化圏に生きる女と別の文化圏で生きる女とでは思想も違えば、社会における立場も全く違うのだ。例えばある国では多くの女性の人権が剥奪され、過酷な暮らしを強いられているという。また仏教における観念の一つに女は穢れであるとされており、月経や出産は死や犯罪と同じくして悪しき状態のものとされていたという。また時を百年、千年と遡ればまた違う女が見えてくるはずであり、私の存在している文化圏から一歩足を踏み出してしまえば女という存在の価値など全く違うものに成りうるのだ。

女である私ですら知り得ない女の姿が存在しているということを改めて自覚すると同時に、女を花で表そうという試みは、私がこの時代に生まれ、この社会や文化の中で育ったからこそ行き着いた結果であり、表現だったのだと気づかされたのだ。もしかしたら、これは女である自分自身を見つめ直し手探りで作り上げた自画像なのかもしれない。先人たちが庭に咲く花を眺めては自身を重ね、歌を詠み、物思いにふけったように、私は花を介すことで、日々抱く思考や感情、願望や使命を、これから訪れる盛衰への希望と恐怖を表現したかったのかもしれない。

今はまだ色鮮やかな咲き姿をもって横たわっている彼女も、じっくりと血の気がひくように色褪せ、褐色がかり、歳をとっていく。そして私もまた同じだけ歳をとっていくのだろう。5年後10年後と時が経ち、彼女と向き合ったとき私はなにを思うのだろうか。

Afterword

Come to think of it, more than two and a half years have passed since her birth: flora. Upon our recent re-encounter, I am at my wit's end once again. I was surprised with the endless answers that line up for our quest, "What is a woman?" What made me realize this is the word itself: "flora". The utmost reason for naming her "flora" was because I wanted a female name with some flower resonance as per this artwork and also because this was the name of the spring goddess in Roman mythology. However, there was another meaning to this word, referring to a "form of plants".

Actually, "flora" is the plant form occurring in a particular time, region, weather, and nature environment. For example, with Japan and the United States, there are completely different kinds of plant form living in each country depending on the environment. Similarly, plants are classified into various plant forms depending on their environments.

The same idea applies to women. Women living in the same culture as myself and women living in a different culture would differ with our philosophy as well as our social status. For example, with some countries, many women are deprived with their rights and are forced to live under harsh conditions. Also for example, at a time, in one belief under Buddhism, women's menstruation and child-birth were regarded as sinful, likened to death or crime. If we go back 100 or 1000 years in time, we would see different women; if I were to step outside of my culture, then the value for women could be completely different from the value of women to which I am accustomed.

Once again, it came to light that various forms of women exist even for myself as a woman: there is no way for myself of knowing. At the same time, the attempt to portray a woman using flowers is a result or my mode of expression that I came across only because I was born in this century and raised in this current society and culture.

Perhaps, this might be a self-portrait as a result of my groping reflection upon myself. Just as how our ancestors might have enjoyed watching flowers in their gardens, sometimes relating themselves with the flowers, possibly by writing poems or getting lost in their deep thought, I, myself might have expressed my daily thoughts or emotion, desire or mission, and/or my hope and fear about my future rise and fall through a flower.

At the moment, even if she appears to be lying down vividly blooming, she will gradually age by fading as if blood is draining out and becoming de-saturated into a brownish colour. The same applies to myself; I will age just like her. If I were to face her again five or ten years from now, I wonder: what would I feel then?

あとがきのあとがき　2013年に自費出版で刊行された本書が、改めて一般発売されることが決まると同時に、偶然にも 5 年ぶりにこの作品と対面することになった。かつての鮮やかさが失われた姿に一瞬、落胆したものの、生命の衰えていく様や、思い通りにならない辛さがそこにはあり、それでもなお、花でいようとする微かな意地のようなものが漂っていた。これを枯淡の美というのであろうか。

私はそのものが持つ独特の美しさを無視出来ず、一度はその姿を、本書に載せようかと考えたが、あの鮮やかな flora がもつ余白を、埋めてはいけないと思いとどまることにした。それはこちらから指し示すものではなく、色鮮やかな姿に潜んでいる、目に見えないものをそれぞれの文化や思想を通して自ずと感じようとするものであり、見る者の心にまた別の感心が訪れるべきなのだろう。そして、その余白は、その時々で違った側面を見せてくれるかもしれない。

現にその余白は、花が意味するのは、単に美しさでも、命あるものだけではなく「移ろい変わるもの」というべきであったことに気づく機会を与えてくれた。色鮮やかな花で形づくられた骨格は、人間の、あるいは女の一瞬を切り取ったものかもしれないが、見る者によっては、悠久の過去、そして未来を垣間みることも可能にさせるのだ。

Afterword
of the afterword

Just as the reprinting of this book was decided, I happened to encounter it for the first time in five years. Although I became disappointed for a second at the lack of its former vividness, I felt that there was decayed life, perverse fate, and still something like a subtle will to be a flower, which might be the beauty of refined simplicity.

Although I could not overlook its own unique beautyand although I tried to include it in this book to be reprinted, I thought that I should not fill up a blank with the vividness of flora. I gave up. It is not what I should showbut something invisible that lies hidden in the vividness, which should be felt spontaneously through individual culture or thought, or which should come into the mind of the viewer as another fancy. The blank might have different aspects from moment to moment.

The blank lends one the chance to find that what a flower means is not only beauty and life, but also "something which moves and changes". The bones formed by vivid flowers might be cut from a moment of a person or a woman and allow someone to catch a glimpse of eternal past and future, depending on the viewer.

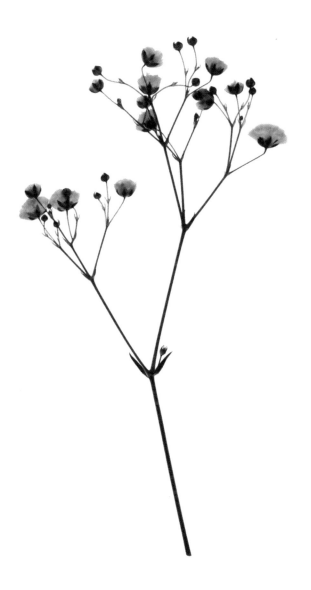

カスミソウ ｜ Gypsophila elegans ［感謝］

多田 明日香

グラフィックデザイナー
1986年 千葉県生まれ
2010年 武蔵野美術大学 基礎デザイン学科 卒業
現在、東京在住

ASUKA Tada

Graphic Designer
1986 Born in Chiba, Japan
2010 Graduated from Musashino Art University Department of Science of Design
Currently residing in Tokyo

flora

2015年7月4日 第1刷発行

著者　多田明日香

発行者　土井尚道
発行所　株式会社 飛鳥新社
〒101-0003
東京都千代田区一ツ橋 2-4-3 光文恒産ビル
電話（営業）03-3263-7770
　　　（編集）03-3263-7773
http://www.asukashinsha.co.jp/

文章・装丁　多田明日香
英訳　　　　長谷川嬢

印刷・製本　中央精版印刷株式会社

落丁・乱丁の場合は送料当方負担でお取替えいたします。
小社営業部宛にお送りください。
本書の無断複写、複製（コピー）は著作権法上での例外を除き禁じられています。
ISBN 978-4-86410-415-9
©Asuka Tada 2015, Printed in Japan

編集担当　花島絵里奈

※ 西畠清順氏、原研哉氏の文章は2013年に本書が
自費出版で刊行された時に書かれたものです。